9/04

Let's Draw with Shapes™

Let's Draw a
Horse with Rectangles

Joanne Randolph
Illustrations by Emily Muschinske

The Rosen Publishing Group's
PowerStart Press™
New York

1

Published in 2004 by The Rosen Publishing Group, Inc.
29 East 21st Street, New York, NY 10010

First Edition

Book Design: Emily Muschinske

Photo Credits: pp. 23, 24 © Digital Stock.

Randolph, Joanne
Let's draw a horse with rectangles / Joanne Randolph ; illustrations by Emily Muschinske.
p. cm. — (Let's draw with shapes)
Includes index.
Summary: This book offers simple instructions for using rectangles to draw a horse.
ISBN 1-4042-2502-1 (lib.)
1. Horses in art—Juvenile literature 2. Rectangles in art—Juvenile literature 3.
Drawing—Technique—Juvenile literature [1. Horses in art 2. Drawing—Technique]
I. Muschinske, Emily II. Title III. Series
NC655.R363 2004 2003-008469
743.6—dc21

Manufactured in the United States of America

2

Contents

Draw a red rectangle for the head of your horse.

Draw an orange rectangle for the neck of your horse.

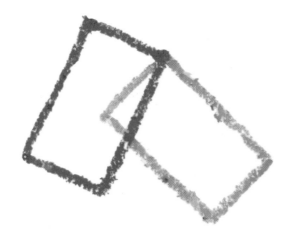

7

Draw a big yellow rectangle for the body of your horse.

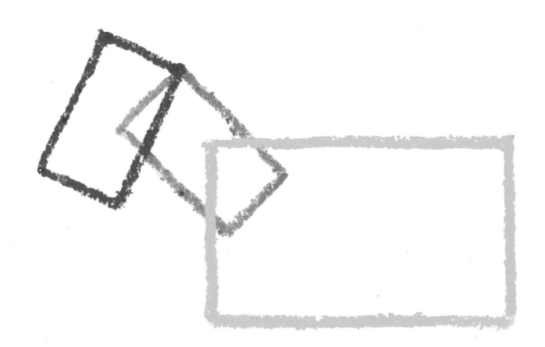

9

Draw two green rectangles for the legs of your horse.

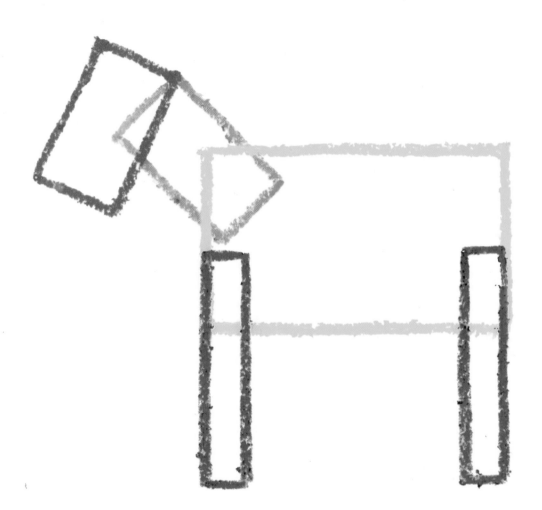

Draw a small blue rectangle
for the ear of your horse.

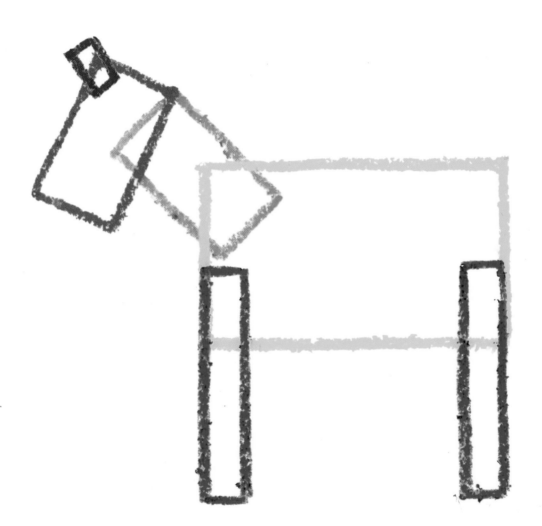

13

Draw four purple rectangles for the tail of your horse.

14

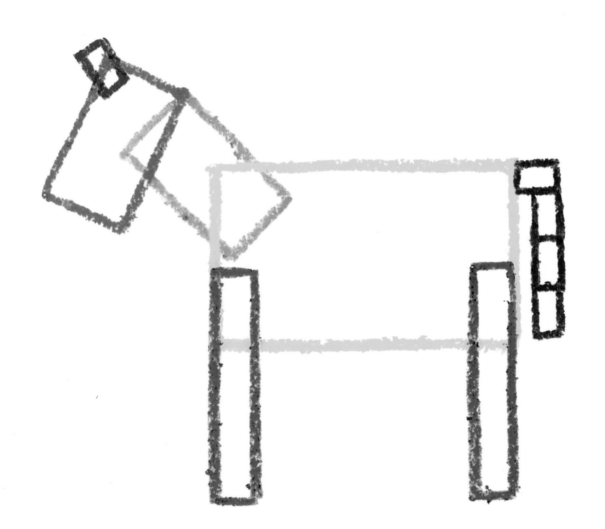

15

Add a pink rectangle to the head of your horse.

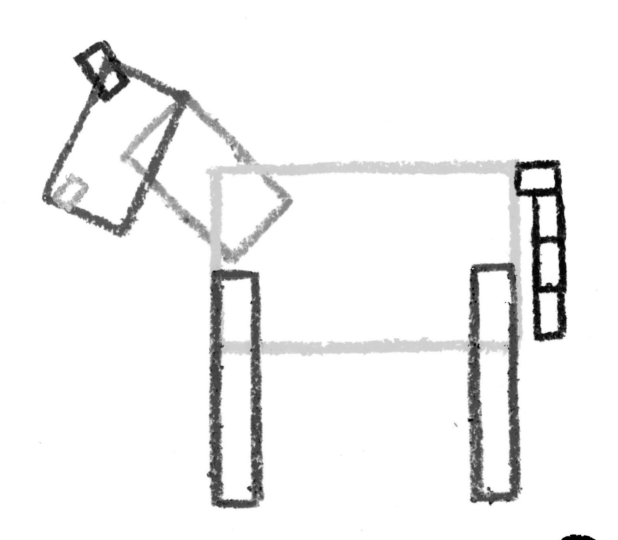

17

Draw a black rectangle for the eye of your horse.

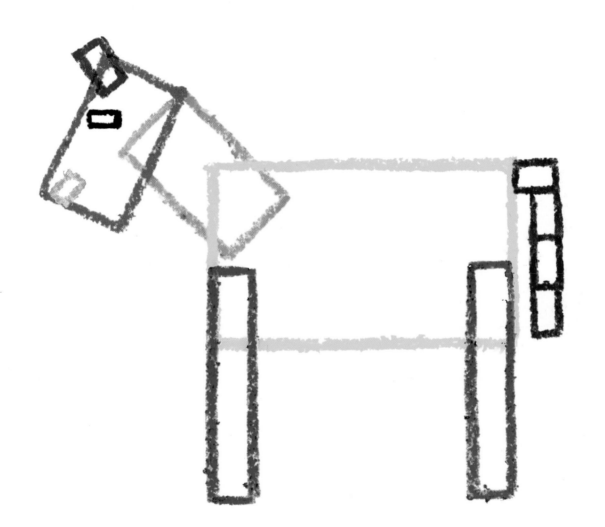

Color in your horse.

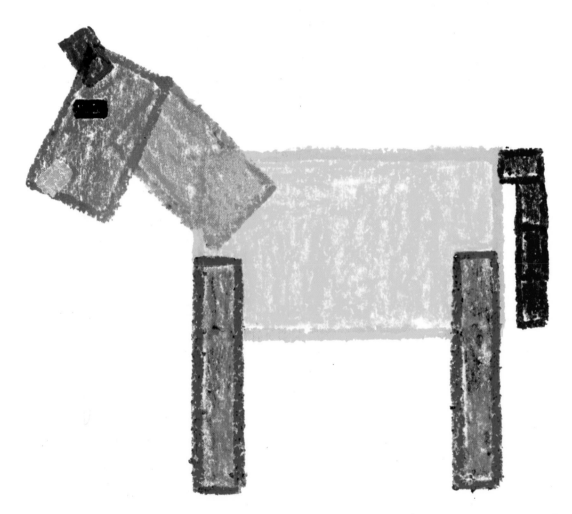

Horses love to run.

Words to Know

body

ear

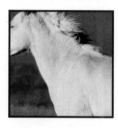
neck

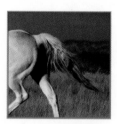
tail

Colors

 red

 orange

 yellow

 green

 blue

 purple

 pink

 black

Index

Web Sites

Due to the changing nature of Internet links, PowerKids Press has developed an online list of Web sites related to the subject of this book. This site is updated regularly. Please use this link to access the list:

www.powerkidslinks.com/ldwsh/horsere/

24